african american quilting

The warmth of tradition

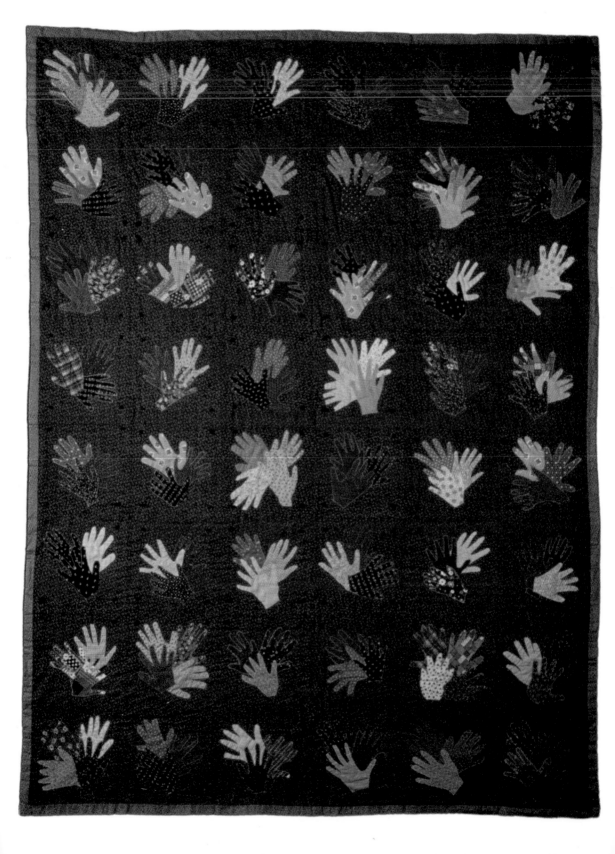

african american quilting

The warmth of tradition

sule greg c. wilson

rosen publishing group, inc./new york

Published in 1999 by The Rosen Publishing Group, Inc.
29 East 21st Street, New York, NY 10010

Copyright © 1999 by The Rosen Publishing Group, Inc.

First Edition

Library of Congress Cataloging-in-Publication Data

Wilson, Sule Greg.
 African American quilting : the warmth of tradition / Sule Greg C.
Wilson. — 1st ed.
 p. cm. — (The library of African American arts and culture)
 Includes bibliographical references and index.
 Summary: Explains the art and craft of quilting among Afro-Americans
and describes its roots in African textiles and traditions.
 ISBN 0-8239-1854-8
 1. Afro-American quilts—United States—History Juvenile literature.
 2. Quilting—United States—History Juvenile literature. [1. Quilts.
 2. Quilting. 3. Afro-Americans Biography.] I. Title. II. Series.
 TT835.W55 1999
 746.46'-089'96073—dc21
 99-18290
 CIP

Manufactured in the United States of America

Contents

Introduction

Hello; welcome to *African American Quilting: The Warmth of Tradition*. What you hold in your hand is a book about the beauty, history, and lore of quilts made in the United States by people of African heritage. Today quilting is not as common as it once was, so we wrote this book to give you a well-rounded, cultured introduction to this artistic craft that was once a do-or-die skill.

To do this, we've got to go all the way around the world. We'll cover the meanings and origins of quilting as well as techniques from Africa, Asia, Europe, and the Pacific. We'll examine African aesthetics—western and central African senses of style and beauty—for clues on how to "read" and appreciate African American quilts. We'll see examples of the European American quilting tradition and how African people have learned that, too. Of course we'll also look at the great masterpieces and masters of African American quilting.

At the end of the book, you'll find a glossary of useful terms as well as information on quilt

books, magazines, organizations, and Web sites that can further your knowledge of quilting.

We hope you'll be inspired by what you read and see in *African American Quilting: The Warmth of Tradition* and that you'll begin making your own quilts—vibrant examples of your creativity and power.

What makes "art" is its life—pulsing and shining with the energy and intentions of its creator. The art of quilting glows with a respect for all the generations that have come before— putting thread, needle, and cloth together with vision and love.

1 what is quilting?

When you hear someone say "quilt" or "quilting," what images come to mind? An exquisitely crafted museum piece, magnificently draped across an elegant bed or polished-wood quilt rack? A picture in a craft or folk magazine? A cherished heirloom, brought out of storage for only special occasions? A splash of color on a country clothesline? A worn-out old throw that keeps your feet warm while you're propped up on the couch, channel surfing? A musty old thing that only Grandma uses?

Most people have some combination of the above images in their brains. The funny thing is, they all are—or can be—true.

Now, when we say "quilter," whom or what do you picture? A little old lady like Sylvester the Cat's owner or a character on BET's *Comic View?* Someone who lives around the corner in a nearby apartment or community center? Perhaps even an

old and yellowed photo of a distant relative holding a blanket that is still in the family?

Well, how about YOU? Quilting can be done by anyone—boy or girl, woman or man. Keep that image with you for a minute.

A Definition

Webster's Dictionary tells us that a "quilt"—the noun—is a bed covering made of soft material (goose feathers, called "down," or cotton or polyester batting) sandwiched between two pieces of cloth that are sewn or tied together. The verb "to quilt" means to fasten something between two layers of cloth.

As you know, there are both store-bought quilts and homemade quilts. Store-bought ones can be beautiful; they are often copies of homemade quilts. But in this book, we're talking about the work of one's very own hands and mind: the homemade quilt.

Nowadays when people think of quilts, it's not the padding or fastening that comes to mind. Instead it's the bold and intricate quilt tops that make you go, "ooh!" or "aah!" But there are actually many different types of quilting, and each has a very different appearance and tradition. The three types discussed in this book are whole cloth work, piecing, and appliqué.

Whole cloth work uses only one piece of cloth for the top of the quilt. Whole cloth technique is often

done using a piece of white fabric to show off the quilter's intricate stitching. For this reason, whole cloth work is also called white work.

Piecing is sewing pieces of cloth together to make a quilt top. Some examples of piecing that you may know already are log cabin quilts, wild-goose quilts, or crazy quilts. Beautiful designs emerge made of patches of different material diligently pieced together.

Appliqué is the sewing ("applying") of small cutout fabric shapes onto a background of another fabric, laid down in a decorative design. People have used appliqué for hundreds—if not thousands—of years.

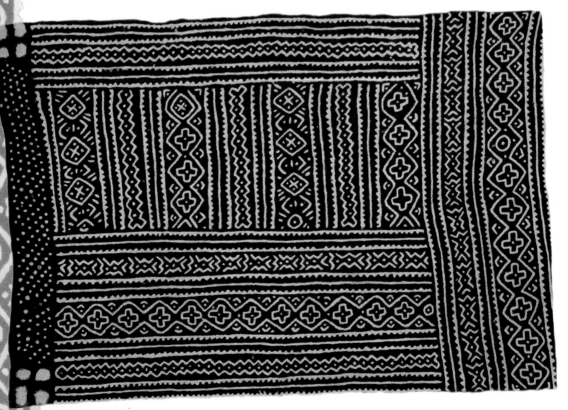

This cotton cloth made by the Bambara of Mali shows intricate appliquéd patterns.

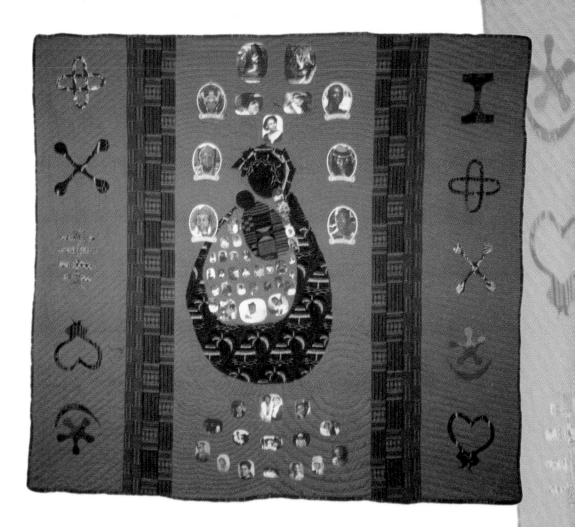

For example, the traditional bark cloth fabric of the Bantu peoples of central Africa is sometimes appliquéd. This technique, following traditional African custom, is often used to depict stories and ideas.

A Piece of Remembrance

In the past, quilting was not just an art; it was a necessity. Until around the 1940s, most people made their own clothes, and nothing was wasted. If clothes wore out, they were patched. If they were worn beyond

This modern quilt was made in America but contains traditional African images, fabrics, and appliqué techniques.

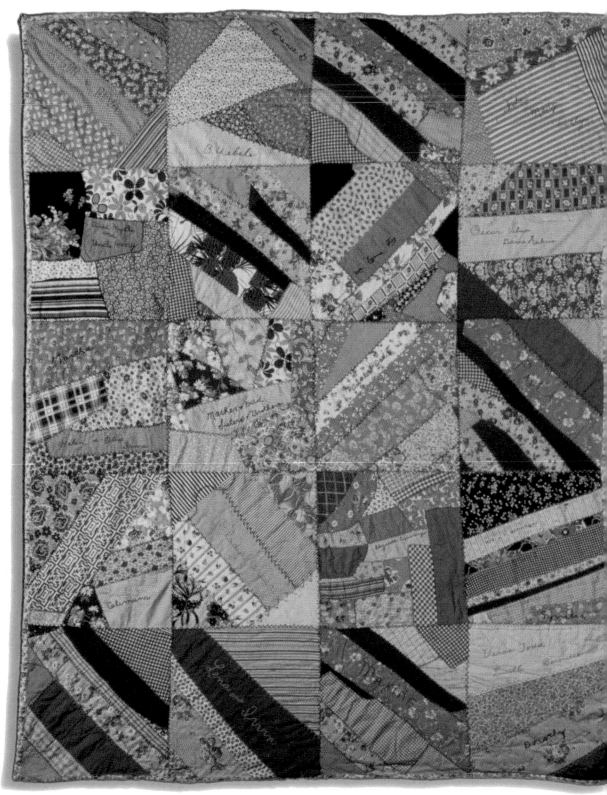

A quilt top made from pieces of your old, worn-out clothes will carry the memories of those special fabrics.

patching, they became scraps for a quilt top or part of a coat's lining. Old quilts were even sewn in as batting for new quilts.

Also, with only the fire to heat the house, people piled on the quilts in order to stay warm on icy winter nights. Some folks remember quilts and blankets so heavy that they could barely turn over in the bed once they had gotten under the covers. But they'd be warm all night, and for two reasons: the insulation and the fact that they were tucked in beneath something made from their family's history.

Quilts take us back to a time when people didn't have television, radio, two or three jobs, or so many meetings to go to and places to be. People spent an evening after a day's work relaxing in the slow creation of something useful and beautiful. Quilts stand for people making do for themselves, using what they had.

Weight and Warmth

What's the big deal about making a quilt from some pieces of torn, worn cloth? Let's look at the big picture. We're surrounded by fabric all day, every day. We have been wearing clothes for years. And part of the purpose of our wearing clothes is to define ourselves. Why do you choose to wear this or that: blue denim, black denim? Polyester double knit? Spandex or cotton/polyester? Khaki? Silk and satin? Camouflage? The choices are endless.

The fabrics you choose have meaning for you: a style or texture you saw and liked, something that was given to you. Your clothes experience life with you; they absorb your emotions and encase your memories: the day you went to the fair, when you met your best friend, a moment of mortal danger, the time you discovered love, the time you lost it. Favorite clothes become a treasure, a magic key to what you remember.

In time, those precious clothes go the way of all things: They wear out, get stained or torn, or go out of style. Then what? Do your old clothes become hand-me-downs, charity giveaways, household rags, refuse, or landfill? Or do you keep them for the memories?

In this book, you'll have another alternative—a new way to not only keep hold of your memories, but also to be ecologically conscious by recycling old fabrics.

Next time you want to get rid of old clothes, don't! Box them or bag them. They'll make great pieces for a quilt. One day, in years to come, you'll look upon that quilt and see the little pieces of cloth—or maybe a whole pant leg—that hold so many memories. That quilt will be heavy with experience and warm with memories of days gone by.

2 a history of quilting

Quilting Goes Back a Long Way

Scholars have noted that the patterns found in West and central African textiles are the same as those in the 4,000-year-old method of cloth wrapping that preserved the bodies of national leaders of the ancient civilization of Kemet. We are lucky to have these examples of an art made of materials as fragile as linen, cotton, and wool.

The oldest known piece of quilted material—in which batting is sandwiched between a top and a backing piece—was discovered in Asia. On the floor of a Scythian chieftain's tomb, dating from between 100 BC and AD 200, quilted material was found that included cross-hatching and contour quilting as well as finely detailed appliquéd animals. So the techniques we utilize today are at least 2,000 years old. Some of the patterns and designs we use are twice that age. Wow!

This textile fragment is from the Nile Valley and was made in the fourth or fifth century AD.

Quilts 'Round the World

Before we examine cotton and other fabrics in Africa, let's look at quilting traditions in other places around the world. Remember, we live on a big planet. Very little is done by just one group of people on Earth.

Below is a brief introduction to a couple of quilting styles and techniques from around the world.

The Palestinian-European Connection

Our modern word "quilt" comes from the Latin word *culcitra*. Since it's a Latin word, we can be pretty sure that the Romans (who spoke Latin) used quilted blankets. However, it wasn't until western Europeans attacked Palestine in AD 1095 and gained direct access to technologies of Asia and Africa that the process of quilting became standard in western Europe.

During this attack, knights from England, France,

16

A fragment of textile made in Europe around the sixth century AD

and Italy were decimated by the local Palestinian soldiers. One reason the Palestinian armies were successful was that they had quilting on their side. Their light armor, made of tough quilted jackets with chain mail on top, was much more maneuverable than the Europeans' heavy metal armor.

After that lesson it became customary for European knights to wear quilting under their armor, and chain mail entered Europe's vocabulary of war.

White work was the only type of quilting done in Europe until the fifteenth century; there was no piecing. Remember: Quilting was not just an art; it was vital to have multilayered clothing, blankets, and wall coverings in drafty stone buildings during a long, cold winter.

Japanese Quilting

In Japan, for this very same reason, there is also a tradition of quilting. The futon bed, a flexible mattress, is

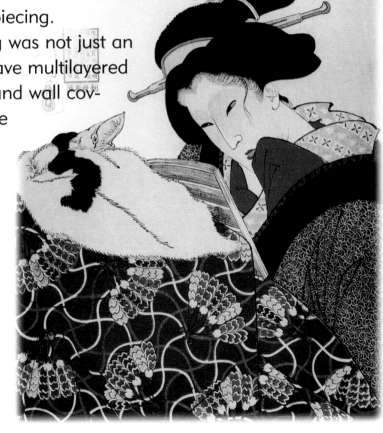

This 200-year-old Japanese painting shows a young woman reading a novel, snuggled under her sashiko quilt.

stitched through and padded like a quilt. The main stove in a traditional Japanese home, the *kotatsu*, is usually covered with a thick quilt to keep the heat in. The kotatsu not only warms the home and makes it hospitable but also shows off the sewing skills of the woman of the house.

There is also the white-work tradition of Japan known as *sashiko* ("little stabs"). This type of patterned cloth is about 300 years old. Traditionally executed with white thread on an indigo-dyed cloth, sashiko artists made wonderful repetitive patterns. The practice of sashiko now includes many forms and colors. Garments of sashiko soaked in water once served as protective gear for Japanese firefighters.

The Ainu people, the aboriginal (first known) inhabitants of Japan, appliquéd cotton in intricate patterns onto their traditional clothing made of elm bark fibers. They used the cotton to strengthen the collars, cuffs, hems, necklines, and backs of their clothes. This work had more than just an earthly function: The Ainu believed that along the spine and at places where wind and cold reach the body, there was a need for another kind of strength—the metaphysical kind. The Ainu placed their patterned cloth at those areas to guard themselves from bad energy, funky vibes, and evil intentions. This use of fabric patterns is similar in purpose to the way that some African American people use their quilts.

Seminole Patchwork

The Seminole are a composite group of Native American people mostly from the Creek confederacy but also containing some Choctaw, Chicasaw, and others. For a time the Seminole nation in Florida also included Europeans and independent African villages of people trying to escape the oppressive U.S. system of chattel slavery, in which human beings were regarded as property.

The U.S. government resented this haven of freedom, and the two Seminole wars were the result. Many people from the Seminole nation were shipped west to Oklahoma along with the other native groups of the region. Others fled deeper into the swamps of Florida. The descendants of those people kept the traditions of the Seminole nation alive.

A Seminole woman wearing native dress

19

By the 1880s most Seminoles wore clothes similar to typical Euro-American dress; their traditional buckskin clothing proved too hot for Florida's climate. However, their knee-length tunics and ankle-length skirts were often decorated with colorful braids and solid strips of cloth. Within a generation this would change. Once sewing machines became a popular appliance in the Seminole nation, people invented a new tradition: Seminole patchwork clothing.

How is this done? They stitch together long, narrow strips of brightly colored cotton. These colorful composite strips are then cut across their length. The vertical "rainbow" strips are then recombined into beautiful new patterns, some straight, some diagonal.

This woman is sewing together pieces of a traditional Hawaiian snowflake quilt.

Hawaiian Snowflake Quilting

Before the import of cotton, native Hawaiian peoples made their clothing from tapa cloth, the pounded and dyed bark of the local mulberry plant. Tapa cloth tears easily when wet, so cotton was quickly adopted. At the same time, Hawaiian royalty were taught needlecraft and quilting.

Soon to develop was a totally new tradition using the "paper snowflake" method of construction—similar to folding over a piece of paper two, four, six, or even eight times; cutting out a pattern; and then opening it up to reveal a delicate and intricate design.

In Hawaii this is done with a piece of colored cloth folded eight times, resulting in a large, lacelike pattern

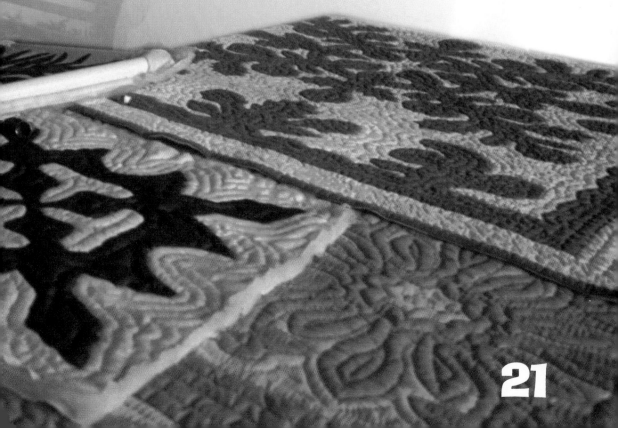

that is then appliquéd to a background fabric. Freehand lines are then stitched around the design using a technique known as echo quilting.

Each snowflake quilt is individually created and imbued with the spirit of its maker. Therefore the meanings and origins of each design are jealously guarded and shrouded in mystery. This is powerful stuff and is not to be messed with.

Tahitian Tifaifai

The *tifaifai pa'oti* (tifaifai appliqué) of Tahiti is similar to Hawaiian style, but Tahitian needlework is not quilted. Brightly colored fabric (traditionally red on white or white on green) is folded in fourths, cut, and then appliquéd. Some Tahitians also work in a style that is obviously Polynesian in influence; others create patterns similar to Euro-American pieced motifs. Large, unquilted patchwork tifaifai pieces are sometimes given to people within a community to express love, respect, and sympathy. As with the Hawaiian snowflake quilts, the origins and meanings of Tahitian patterns are kept a secret.

The quilting traditions don't stop there! Around the world you can find Laotian *Hmong* patchwork, India's *shisha* appliqué, Chilean *arpilleras*, Panamanian *molas*, Italian *trapunto*, French *boderie perse*, and of course, from Africa, *Dahomean* appliqué.

The world of needlework is a big one; enter with pride.

3 textile work in africa

Africa is a big place. All of the United States east of the Mississippi River could fit within the Kongo (formerly called Zaire). And that's just one country on the African continent! The continental United States can fit into the continent of Africa almost three times! That is a lot of room to move around in. In the country of Nigeria alone, there are over 200 different languages, and there are hundreds more throughout Africa's forty-four independent nations!

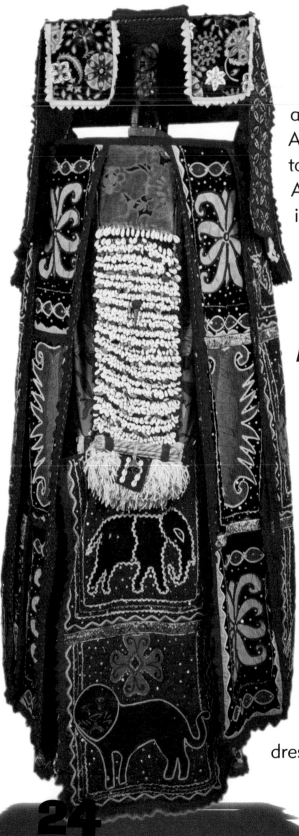

Among the technological and functional riches that Africans have is the ability to make and use fabric. And that's where we come in—with the making of quilts. Let's look at the development of these fabric-working talents.

Ancient African Cotton

Wild cotton is naturally found in West Africa on the fringes of the Sahara Desert as well as in the Asian floodplains of the Indus River. There is evidence of cotton cloth in southwestern Asia between 3000 and 2500 BC, just 1,000 years after the people of Kemet (ancient Egyptians) were depicting human beings dressed in fabric (either cot-

This elaborate robe adorned with wood and shells was made by the Yoruba people in the Republic of Benin.

ton or linen). Maude Southwell Wahlman, PhD, has also found quilting in ancient Egyptian robes.

In warm West Africa, thick quilting was the armor for mounted warriors and their steeds. Soldiers and noblemen were padded to the hilt. Even today in northern Nigeria, Ghana, and Niger, the

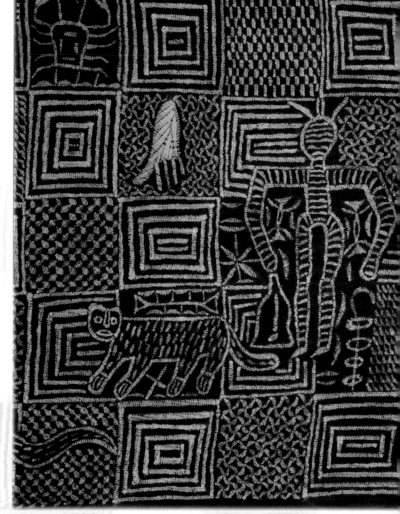

cavaliers of sultans and chiefs parade in their quilted finery for ceremonial occasions. Perhaps the ancestors of today's African Americans produced such quilting and brought their skills and memories to the New World.

There is evidence that cotton fabric was being produced in the upper Nile Valley between 500 BC and AD 300. This is the same time as the introduction of the camel from Asia into Africa and of the Great Dispersion of Kemetic culture. Many people fled south and west to

This cotton cloth was made during this century using materials and techniques similar to those developed thousands of years ago.

escape the invading Greek and Roman colonizers.

At this time iron-smelting technology and, we assume, textile technology moved west from Meroë to ancient Ghana, from the Nile to the Niger. Archaeologists have found multistrip woven cloths made by the Tellem people of central Mali, which date back to the eighth century AD. Thus, after only a few hundred years, we find the narrow-loom tradition of West Africa, a major component of the U.S. style of quilt design.

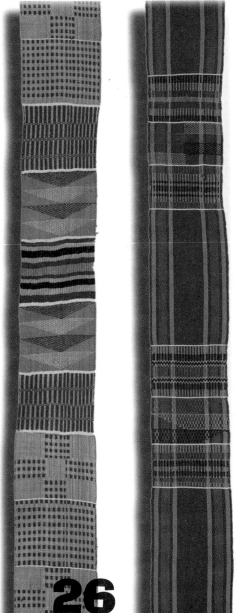

Narrow Weave

Narrow-strip weaving technology—the production of a long, narrow piece of material no more than three inches wide—is a hallmark of West African textile work. These narrow-woven pieces are used to make garments. Because the strips are loosely attached, they allow the clothing to breathe, which is very important in a humid environment!

Working with many strips of cloth also allows the weaver to

Kente cloth was originally restricted to members of royal courts and has always been highly prized.

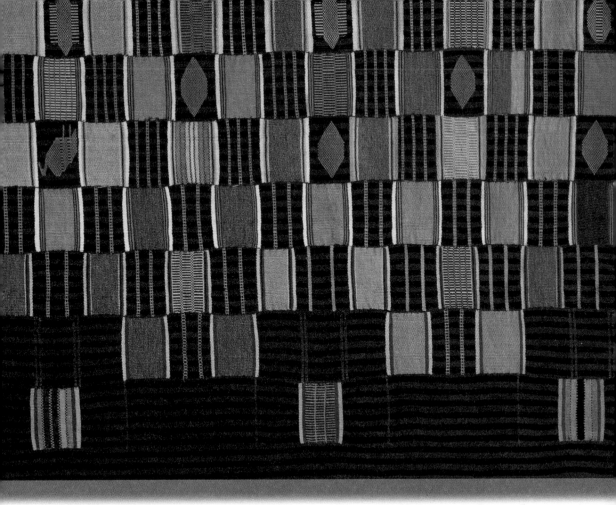

play with the pattern, rhythm, and overall impression of the design. Some people who look at these textiles with an outsider's view might see pattern parts that don't exactly line up as a mistake or lack of expertise on the part of the weaver. But look again! All the strips of cloth that make up the complete piece of fabric line up at both the top and bottom. This is mastery of the loom, and what you are seeing is creation in a different, funkier style. Dr. Robert Farris Thompson of Yale University calls it "visual syncopation."

Fluid patterns and innovation are a hallmark of

Patterns woven into cloth were deliberately offset to create "visual syncopation."

Some say that producing cloth with offset (misaligned) patterns or multiple motifs is done to help keep the wearer safe. Folks say that evil can only travel in straight lines: A complicated or broken pattern is a distraction and means that bad vibes can't get through. In China, people sometimes make crooked bridges for this same reason. If there's a complicated pattern going on, it is believed that the bad-intentioned spirits will get tangled in it. People have wallpapered their homes with newspapers so that bad spirits will stop to read the writing on the walls. Some African Americans will leave a Bible open at night for the same sort of protection.

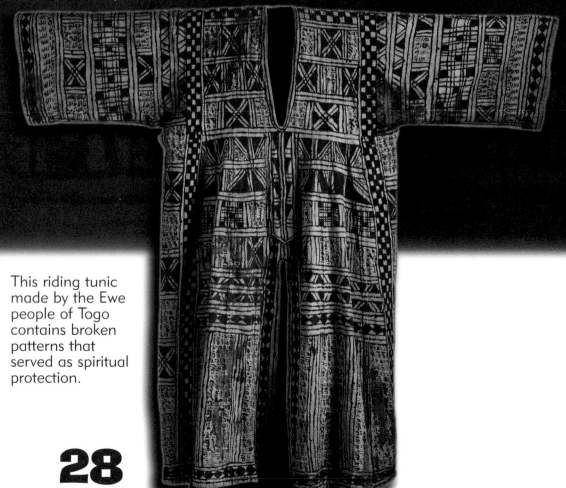

This riding tunic made by the Ewe people of Togo contains broken patterns that served as spiritual protection.

African cultures—whether in oral language, musical improvisation, dance, architecture, or the art of textiles. If we examine African American quilts or textiles from other African peoples in the Americas—Suriname's Dyuka, for example—we can see the preference for patterns that flow in slender strips, as though they came off of a Mande or Ashanti narrow loom.

Strip quilts made from long, narrow pieces of material are often among the first projects of African American novice quilters. They learn the "dos" and "don'ts" of quilting by making a piece in the style of West African narrow-loom fabrics.

The court weavers of seventeenth- and eighteenth-century Ashanti and Ewe *henes* (kings) and *hennmas* (queen mothers) of West Africa developed masterpieces in the narrow-strip style. The Akan Asadua cloth, commonly referred to as *kente*, is considered to be the most labor-intensive fabric per square inch known to humankind. With silk and cotton, color and pattern, the Old Ones wove their traditions. When we use these traditional fabrics, we are calling upon them.

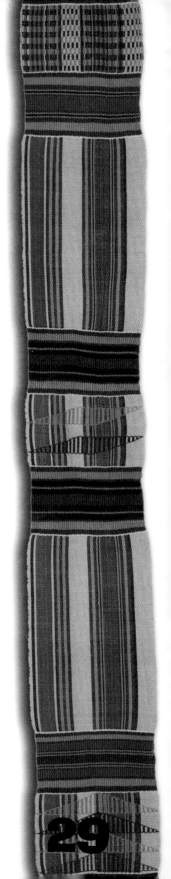

Kente cloth made by the Ashanti people of Ghana required many hours of careful labor.

Asadua Meaning

Here is what some colors in Akan Asadua culture mean:

Gold represents wealth, and joy

White is usually worn by priestesses to symbolize deities or spirits of the ancestors.

Green may be worn by young girls to suggest newness, freshness and puberty.

Black can stand for melancholy or vice, devils, old age, death or even history.

Red is commonly worn for loss, sadness, death or dissatisfaction. Sometimes it's worn to political meetings to indicate anger.

Scholars and researchers have interviewed African American quilters. Sometimes, if they are asked the right way, the master craftspeople will reveal the meaning of their colors.

What could you find out? Are there quilters in your family? In your church? Your neighborhood? If you don't know, then search. You'll be amazed with what you'll find.

Don't be surprised if it takes a long time to discover the secrets. If the answers were easy to get, they wouldn't be secrets, now, would they?

The patterns of African textiles, like the ones worn by these Asadua children, are often full of symbolic meaning.

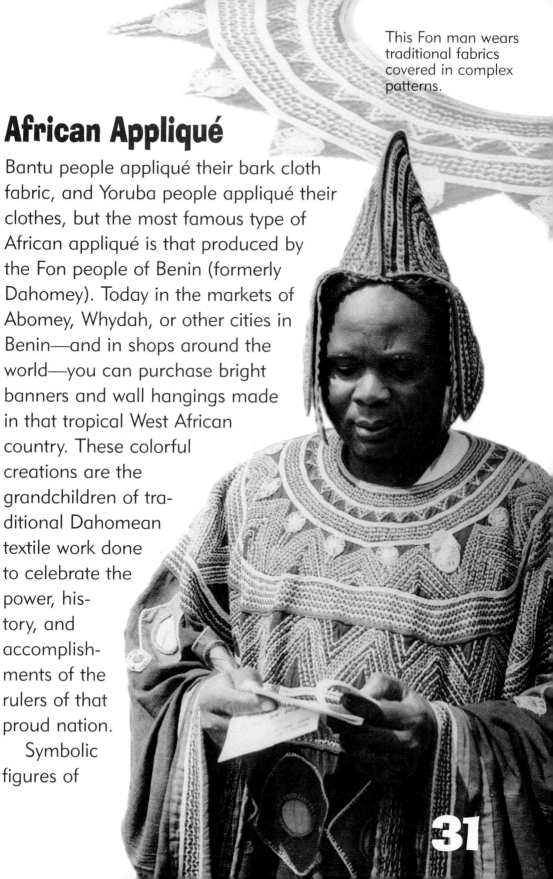

African Appliqué

Bantu people appliqué their bark cloth fabric, and Yoruba people appliqué their clothes, but the most famous type of African appliqué is that produced by the Fon people of Benin (formerly Dahomey). Today in the markets of Abomey, Whydah, or other cities in Benin—and in shops around the world—you can purchase bright banners and wall hangings made in that tropical West African country. These colorful creations are the grandchildren of traditional Dahomean textile work done to celebrate the power, history, and accomplishments of the rulers of that proud nation.

Symbolic figures of

31

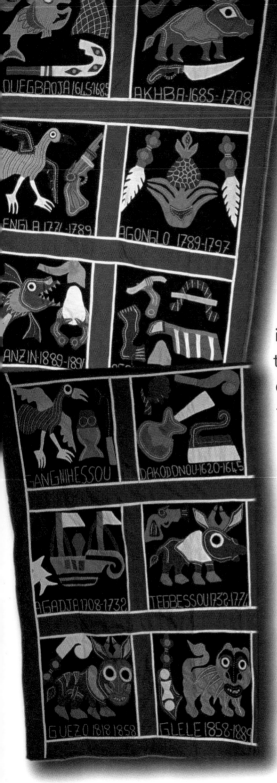

Within the banner images, the following labels appear:

OUEGBADJA 1645-1685
AKHBA 1685-1708
ENGLA 1771-1789
AGONGLO 1789-1797
ANZIN 1889-1891
GANGNIHESSOU
DAKODONOU 1620-1645
AGADJA 1708-1732
TEGBESSOU 1732-1774
GUEZO 1818-1858
GLELE 1858-1889

people and animals (including animals as people) were cut from brightly colored cloth and sewn onto a backing of black, gold, or white material. Human figures were always cut from red or black cloth. Made into banners and flags or sewn to ceremonial umbrellas, these image-covered pieces were used to recount battles, executions, and the legendary powers of fierce kings of this warring nation. The ancient kingdom of Dahomey is famous for its "amazon warriors": female fighters with extraordinary prowess.

These ceremonial appliquéd fabrics were paraded on public occasions, and songs describing the images and their messages were sung for all to hear. The eleven kings of Dahomey are identified through totem animals: buffalo, pig, fish, bird, rooster, lion, and more.

This traditional appliquéd banner from Benin depicts brightly colored images of animals and illustrates historical events.

4 pick up a needle: quilting in america

African Style 'Cross the Waters

For four hundred years, people from many nations (Mande, Akan, Yoruba, Benin, Ibo, Ewe, Kru, Malagasy, Kongo, Angola, and Swahili) were captured in raids, beaten, chained, and marched to the coast. There they were locked up in forts called factories—slave factories. These forts were trading posts where kitchen utensils, beads, fabric, guns, and ammunition were traded for gold, food,

African American slaves of all ages were forced to work picking cotton on plantations.

leather, wood, ivory, and human beings. The unfortu-
nate people who were captured and sold wound up in
Russia, Dominica, Mexico, Pakistan, Peru, India,
Cuba, Jamaica, Brazil, Trinidad and Tobago, Oman,
Suriname, the United States, and many other
countries.

This tragedy meant that these people had to learn
new ways to survive and express themselves in a hos-
tile environment. New inhabitants of the Americas had
many lessons to learn: what to eat, how to prepare the
ground, how to dress for the climate, and how to sur-
vive. Remember, when Africans were brought to the
Americas, they were "imported" as working machines,
not as people with their own beliefs. Those who stuck
to their own traditions were punished.

In response, many aspects of African culture went
"underground." African American slaves devised inge-
nious ways of keeping memories of their homeland—
and their sense of self-respect—alive. Even though
most captive Africans were not allowed to bring any
of their belongings through the Middle Passage to
their place of enslavement, their memories, traditions,
and talents came with them, etched into their spirit.

One way this happens—even today—is through the
learning and passing on of the quilting methods of
African American peoples. Quilts, full of hidden power
and meaning, enable us to live in the warmth of
tradition.

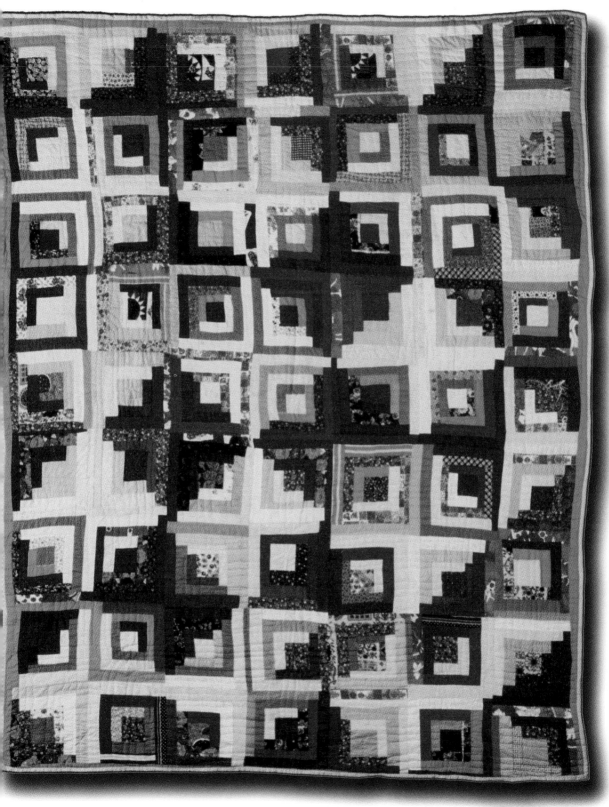

A quilt is both a keepsake full of memories and a true
work of art that is beautiful to behold.

35

Traditions Weave Together

The first records of quilts in what would become the United States come from wills and estate papers of the 1600s. The oldest surviving American quilt is probably the Saltonstall quilt, believed to have been made around 1704. The oldest African-made quilt we know of is about fifty years younger than that.

Many cultures have come together in the United States to include such world-noted quilt styles as Amish, Quaker, Shaker, Dutch, Scandinavian, and African American. In contrast to the traditions of

Many hands and many lives often come together to make one quilt.

Africa, in which the men wove the cloth, European tradition looked to its women to provide clothing. The making of quilts became a creative and social outlet for women often isolated on remote farms.

Groups of women would gather for a "quilting bee." Sometimes they would prepare a quantity of squares, strips, or triangles at home that would be transformed at the bee into a

Quilting bees are a way for women of all ages to get together to tell stories and share wisdom.

nine patch, log cabin, Jacob's ladder, wild-goose, or other quilt-top pattern.

At the quilting bee, women would share news and fellowship as they sewed patches, prepared strips, or quilted layers. Sewing techniques, love and sorrow, stories, and camaraderie were also shared. There are many accounts of the warmth and joy experienced by friends as they sat about the quilting frame, stitching together a quilt top or sewing the layers of fabric together.

Connections

There is an old quilting pattern popular among many African American quilters known as "wild-goose chase." It has rows of triangles separated by wide strips. If we look to Africa for a similar pattern, we learn that among the Ejaghan and related peoples of Nigeria, West Africa, they use triangles to symbolize leopards' spots (a sign of power), a journey, or a path of footprints. That sounds similar to a "wild-goose chase," doesn't it?

All the while, the methods and customs of quilting were changing. The techniques and often the symbolism of many different cultures, from African to Amish, were coming together to create a new, *American* quilting tradition.

This change can be seen in an early nineteenth-century quilt from New Orleans, Louisiana, which has a beautiful floral design appliquéd upon it. It seems at first like a traditional Euro-American piece of appliqué work. But if you look closely, you will notice a circular design that is not merely decorative: It is a snake, a symbol of wisdom and spiritual power in the Kemetic, Christian, and Vodun traditions.

A quilt top with the traditional wild-goose chase pattern.

Quilting for Freedom

Did you know that there is a quilt pattern named underground railroad? Did you know that as African Americans moved north to escape the confines of the legal slavery system, they would sometimes look for quilts?

That's right: A brightly colored quilt—in the right pattern, hanging on a clothesline outside someone's home—was a symbol that this was a "safe house," a stop on the Underground Railroad. Other quilts, through their patterns and colors, pointed out the way or counted the distance to the next "station stop" on the Railroad. Thousands of

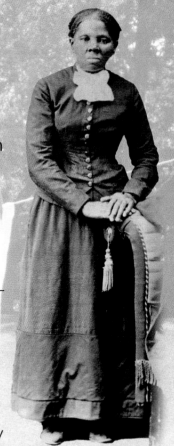

Harriet Tubman

Africans used this secret route to move from the farmhouse of a sympathetic European American family, to a free Black family's barn, to a church basement, to a hidden compartment in a wagon, to a hole in a riverbank, slowly making their way to freedom.

Symbols known only to those that needed to know helped folks to escape, or "steal away." They "followed the drinking gourd" (the Big Dipper) to a new home and the chance for a new life.

Famed Ashanti American freedom fighter Araminta ("Harriet") Tubman, who escaped from slavery in Maryland and returned to the South nineteen times to

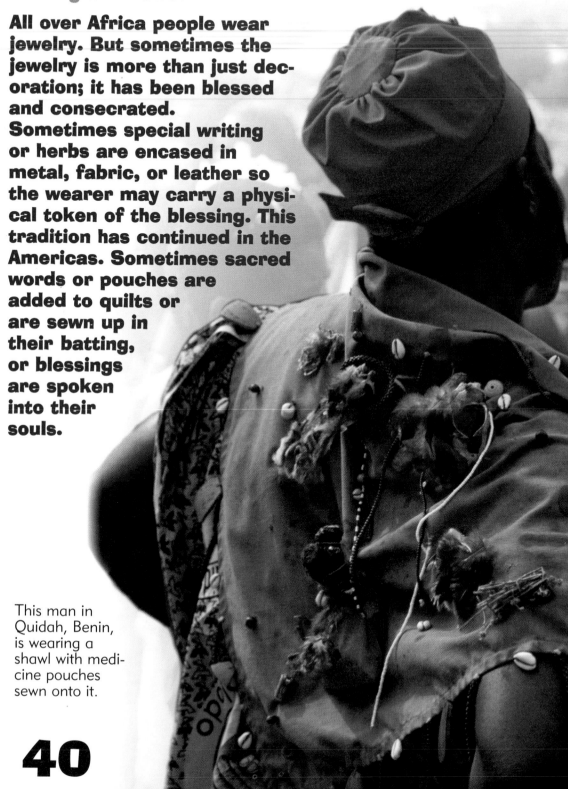

Healing and Power

All over Africa people wear jewelry. But sometimes the jewelry is more than just decoration; it has been blessed and consecrated. Sometimes special writing or herbs are encased in metal, fabric, or leather so the wearer may carry a physical token of the blessing. This tradition has continued in the Americas. Sometimes sacred words or pouches are added to quilts or are sewn up in their batting, or blessings are spoken into their souls.

This man in Quidah, Benin, is wearing a shawl with medicine pouches sewn onto it.

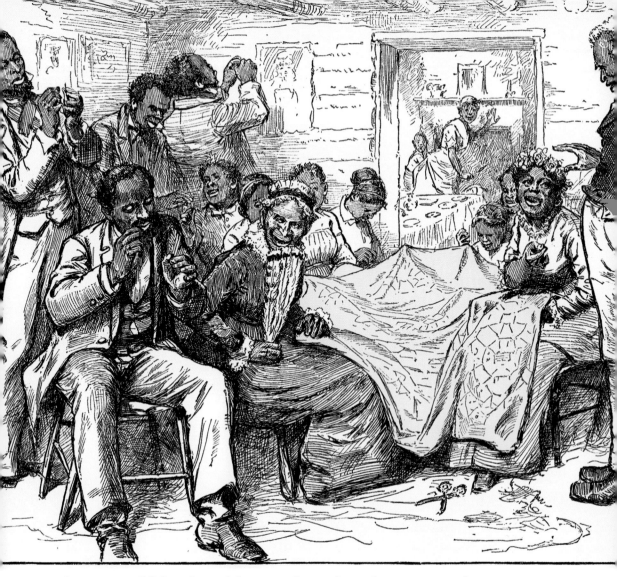

free over 300 other Africans from bondage, was also a quiltmaker. What stories could she tell us; what secrets might she share with us now?

African American Quilters

Quilts are legacies to the lives of their makers. Let us look at and learn from some famous women of the cloth.

"... the precious burden in her lap [was] encased in a clean flour sack, which was still enveloped in a crocus sack. After giving me a full description of each section with great earnestness, she departed but has been back several times to visit the darling offspring of her brain."

Mrs. Harriet Powers, 1837–1911

Harriet Powers: The Bible Quilts

Born a slave in Georgia on October 29, 1837, Mrs. Harriet Powers is known for her masterpiece Bible quilts. Bible quilts are appliquéd and depict scenes from the Bible: Adam, Eve and the Serpent, the Crucifixion, Jonah and the Whale—whatever the quilter decides.

Bible quilts are made with the same intent as Benin banners: to tell a story. Although she could neither read nor write, Mrs. Harriet Powers was a master story-teller through her quilts. She used the same type of appliqué work that is done in Benin, with the transmission of history and spiritual power in mind.

Harriet Powers's quilt of fifteen appliquéd panels was displayed in 1886 when the city of Athens, Georgia, held the cotton fair, which was even bigger than the annual county fair. Mrs. Powers's quilt depicted Bible stories as well as historic events: record cold temperatures of 1895, a phenomenal meteor shower of 1833, and the "Dark Day" of 1780.

A Euro-American woman, Jennie Smith—herself an artist and art teacher in Athens—was at the cotton fair and saw Mrs. Powers's quilt. Recognizing a masterpiece, she hunted down the maker and offered to buy it. Mrs. Powers said no.

Every once in a while, Ms. Smith would check up on Mrs. Powers and her work. Five years later financial

hardship forced Mrs. Powers to sell the quilt to Ms. Smith. Ms. Smith wrote an eighteen-page document about the quilt and its history, in which she describes the day Mrs. Powers brought her the quilt.

It's a shame that Mrs. Powers had to sell it. But because she did, we can now all take pleasure in it and learn of its meaning.

In 1895 Ms. Smith had the quilt sent to the Colored Building (African American Exhibition Hall) of the Cotton States Exhibition in Atlanta, Georgia. Because of this, the wives of some Atlanta University professors saw the Powers quilt. They then commissioned Mrs. Powers to produce another narrative Bible quilt—this one as a gift to the Reverend Charles Cuthbert Hall, chairman of the Board of Trustees of Atlanta University in 1898. Thus another masterpiece was created.

Ms. Smith kept the first quilt until her death in 1946. The executor of her will held onto it for a while, then donated the quilt and its handwritten description to the Smithsonian. The second quilt made by Mrs. Powers was sold by Reverend Hall's son after his father's death to an art dealer, who donated it to the Boston Museum of Fine Arts in 1964.

Mrs. Powers, who died in 1911, had three children who moved away from the old family farm to the North during the 1890s. It wasn't until 1996 that Harriet Powers's descendants learned of her work and visited her quilt in Boston. Let's take a look at it.

44

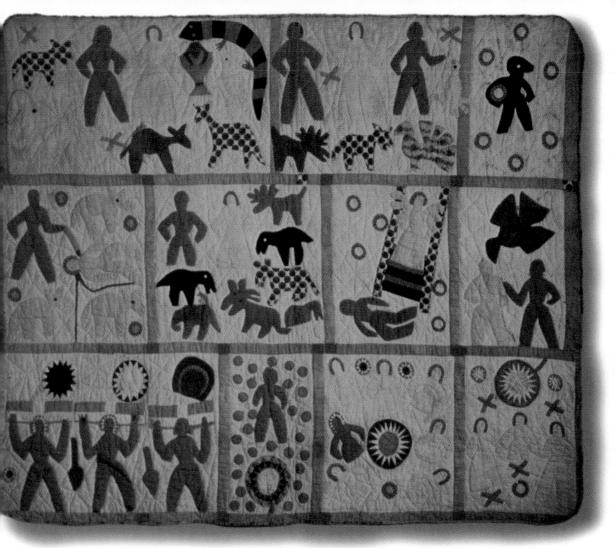

Mrs. Powers's Bible quilt

The quilt is full of sparkling suns and crosses. In numerous African traditions, crosses and suns are symbols of the power of the Spirit. Look again: Don't the people and animals look dynamic, almost as if they're moving? Notice how each picture panel takes its own space, not necessarily lining up with the one below. The final effect is beautiful.

Compare Mrs. Powers's animals to those of the artisans of Benin. They could be made by the same hand.

Look at the chunkiness of their bodies, the way the animals are depicted as silhouettes with eyes. Given this style, it's not hard to believe that Mrs. Powers learned appliqué technique from a needlework master from Abomey. The quilt we know about was obviously not the first one that Mrs. Powers made. What other powerful fabric works did she, and others like her, produce that will never be known?

Elizabeth Keckley: First Seamstress

Elizabeth Keckley was another foremother of today's African American quilters. She was so skilled at sewing that while still a slave, she used this ability to support seventeen people, including the family of her then-impoverished owner. In 1855 she bought freedom for herself and her son for $1,200. The freedom

This painting by traditional artisan Cyprien Tokoudagbaof shows the chunky style of Abomey artwork.

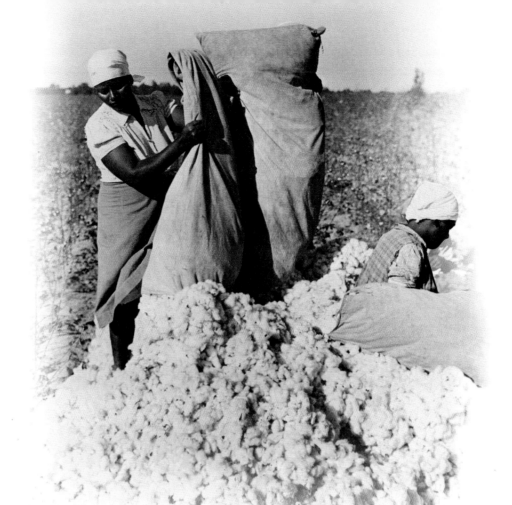

Weaving and Sewing During Slavery

Plantations were self-sufficient places. Everything that was needed was made right there. Workers would grow cotton, gin it (remove the seeds by hand or, after 1793, by machine), spin it, dye it, weave it, and sew it. African women came to America with many of these skills already, and they were certainly put to use. Weaving and sewing is hard, time-consuming work, and people trained in such specialized work were always in demand. Skilled African sewers could fetch a price of $1,000 or more on the auction block! Remember, this was a world where regular people were earning only ten or twelve dollars a year!

Women harvesting cotton on a farm in Mississippi

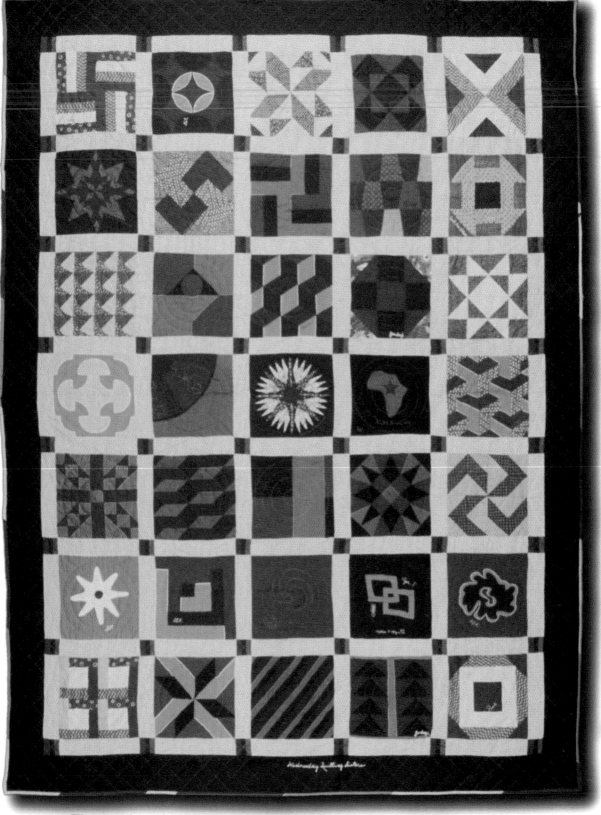

This modern American quilt has motifs from both African and European traditions.

money was put up by a society woman in St. Louis, Missouri, for whom Mrs. Keckley sewed; she quickly repaid the debt using her sewing skills.

She later moved to Washington, DC. Keckley's skills as a seamstress were so well known that when President Abraham Lincoln and his wife, Mary Todd Lincoln, moved to the nation's capital in 1860, Mrs. Lincoln immediately retained Mrs. Keckley as her personal seamstress. There still exists a quilt made by Mrs. Keckley that includes, it is believed, scraps from Mrs. Lincoln's gowns. Mrs. Keckley was also a great humanitarian; look her up!

Martha Ann Ricks's Gift to the Queen

In the 1800s one response to the U.S. chattel slavery system was to get out from under it—by leaving the country. The West African nation of Liberia was founded by African Americans returning to their motherland, as Sierra Leone was founded by Africans from British colonies in the New World. They brought back with them skills acquired in the States; one of these was quilting.

In the late nineteenth century, one of Liberia's best quilters was Martha Ann Ricks. According to quilt historian Cuesta Benberry, she created "a quilt which showed a complete coffee tree all in green and yellow on a white ground, its branches and leaves perfectly formed,

49

the flowers at the root of the leaves and its berries—
exquisite in tracery and workmanship. The design was so
unique and true to nature that it was admired by all who
saw it."

On July 18, 1892, Ms. Ricks and Jane Roberts, the
wife of the first African president of Liberia, presented
this quilt as a gift to Queen Victoria, "Queen of Great
Britain and Empress of all India, Victoria Regina," at
Windsor Castle in London. The following year Queen
Victoria sent the quilt to be exhibited at the World's
Columbian Exposition in Chicago, Illinois.

Liberia

5 quilting today

Quilting remained popular in the United States throughout the 1800s, with crazy quilts (made of irregular pieces of fancy fabric) becoming all the rage at the turn of the century. Quilts went in and out of fashion with the next generations. The onset of the Great Depression made quilting a mainstay of "get-by" living, yet with the

migration of Americans to cities and suburbs between the 1940s and the 1960s, quilts were on the outs again. However, the 1970s brought them back as high art. Galleries and museums like the Whitney Museum of American Art held exhibitions displaying the wonders of quilts. Today many quilters are using their artistic talents to create political and social statements meant for the wall, not the bed.

Quilting—whether created for clothing or armor, banners, beds, or galleries—has come a long way. And this ancient tradition will continue far into the future. The ancestors come when you call, and the calling is the pattern, the colors, the swaying, the style.

Freedom Through Quilting

In the tradition of Elizabeth Keckley, some African American women in rural Alabama have taken their quilting skills and their ability to work together and formed a cooperative that has provided them with international recognition, a new livelihood, and an increase in income by several hundred percent. The Freedom Quilting Bee was founded in 1966 in response to the Reverend Dr. Martin Luther King Jr.'s work in the area, and it is still going strong.

As Mrs. Estelle Witherspoon, manager of the Freedom Quilting Bee, says, "I got that faith in the Lord, and I got the strength and the courage to try to

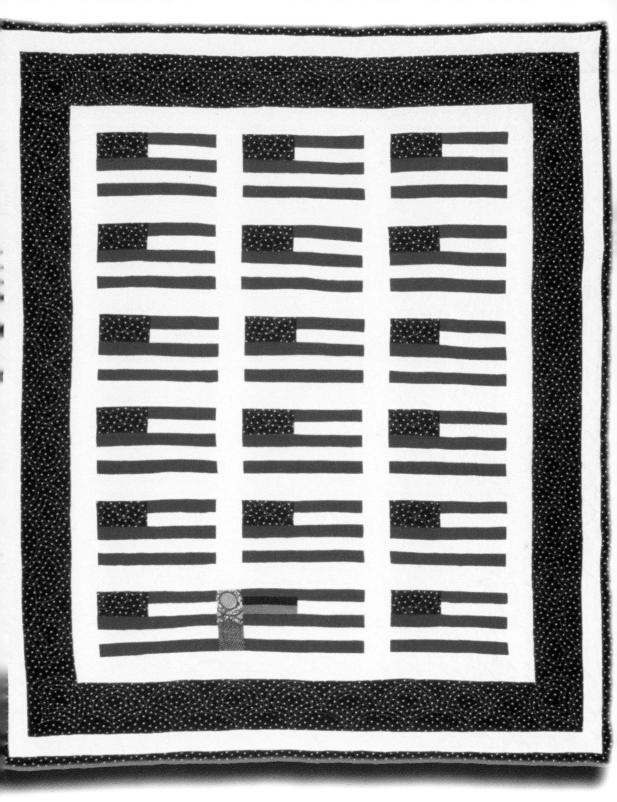

This modern quilt, called simply *Flag*, exemplifies how the art of quilting embodies both African and American traditions.

53

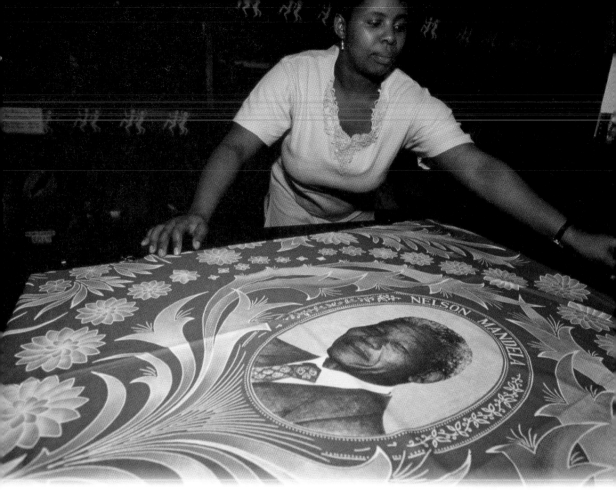

keep on. You can't sit down, now, 'cause the Lord ain't gon' step down here and hand you this one in your hand. You gon' have to get up and go get it. That's the way I feel about it."

In Soweto, a former African-only township outside of Johannesburg, South Africa, a similar quilting project is under way. Entitled the Zamani Soweto Sisters Council, the Sisters on the other side of the world are sharing quilting skills and managing this self-help group.

This South African textile worker has a piece of fabric with a large picture of Nelson Mandela in the center.

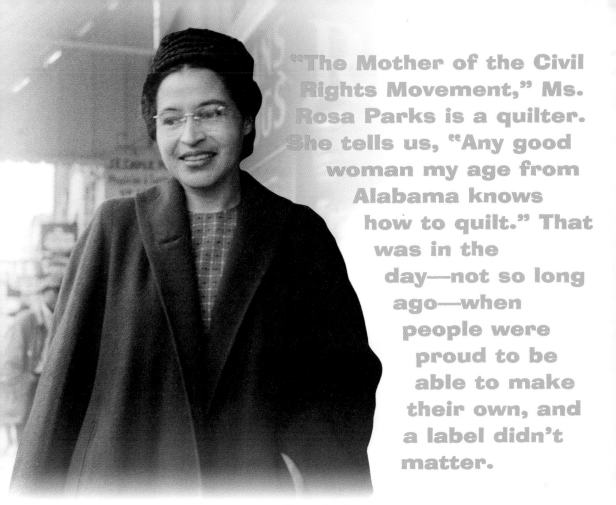

"The Mother of the Civil Rights Movement," Ms. Rosa Parks is a quilter. She tells us, "Any good woman my age from Alabama knows how to quilt." That was in the day—not so long ago—when people were proud to be able to make their own, and a label didn't matter.

Rosa Parks

Outroduction

We have found that fabric and its many forms have a history thousands of years old, traced back to ancient Kemit, Scythia, and the kingdoms of western and central Africa. We have learned that a quilt can be a showpiece of one's skill at needlecraft, as in Europe, the United States, and Japan. We have seen that fabric can tell stories, as in the Fon tradition or an American Bible quilt. It can be decorative and—at the same time—hold hidden messages in color, design, and pattern.

55

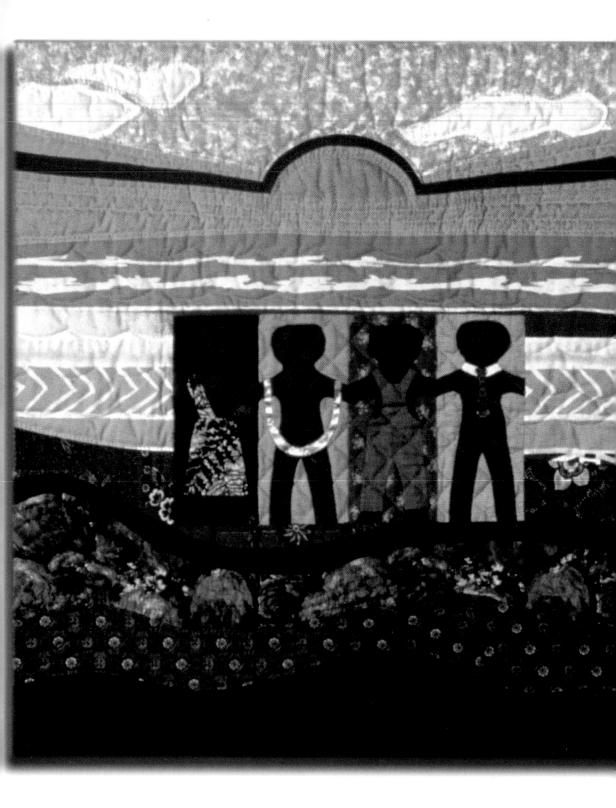

56 This quilt, *Migration*, depicts scenes of the African American experience, from the African homeland to modern professional America.

As for you, dear reader, step forward and create what you will. Why? I'll give you two perspectives on it.

First I'll paraphrase my Uncle Hugh, who I lived with in New York City for a time. He had this observation to make: "Nephew, I see you sitting here on the phone for hours talking with your girlfriend in Philadelphia. Ya know, if you write her a letter, you'll have a solid thing that you can go back to and hold and will help you remember. With what you're doing, in the end all you'll have is an old long-distance bill."

Now apply this truth to the life of a quilt that you have made. The piece you make today is a bridge between you and the future; it is a tangible creation imbued with your life, vision, and love that you—and someday maybe your great-great-grandchildren!—can touch and hold.

Thank you for taking this voyage of discovery with us. It has been a blessing uncovering and preparing this information for you. I hope this book has provided you with some historical and cultural perspective and, perhaps, inspiration. May it serve as a stepping-stone to what's next in your life. As you embrace this artistic craft, who knows where—and when—it will take you?

God Bless. Ashé (grace).

Sule Greg C. Wilson, Antrim, Northern Ireland, November, 1998

Amish A religious/cultural group in the United States that maintains nineteenth-century technology and has a quilting style noted for its use of solid, dark fabrics and striking geometric patterns.

appliqué The technique of sewing small, cutout pieces of fabric onto a cloth background in decorative designs, such as animal or floral motifs.

Ashanti One of the Akan-speaking peoples of West Africa, famous for their kente cloth.

backing The third piece of a quilt (top, batting, backing), usually of plain, sturdy material.

batting The layers of stuffing in the middle of a quilt, which give it its thickness, heaviness, and warmth.

BET (Black Entertainment Television) A cable TV network that features African American comedy programming.

Bible quilt A quilt that depicts scenes from the Bible in appliqué. The most famous Bible quilt was made by Harriet Powers.

crazy quilt Quilts with piecing made of irregular scraps of fabric in no set pattern.

metaphysical Beyond the physical; of a spiritual or religious nature.

Palestine An ancient region of the Middle East bordering on the Mediterranean Sea, where medieval Europeans first encountered quilting and chain mail.

piecing To assemble a quilt top by sewing together pieces of fabric along their edges.

quilt A blanket or hanging made by sewing together two pieces of cloth, usually cotton, with layers of batting between them.

sashiko Means literally "little stabs"; traditional white-work quilting of Japan.

Scythia Ancient region of western Asia from which was found the earliest-known piece of quilted fabric.

Seminole piecing/patchwork A method adapted from the bright patchwork of the Florida Seminole nation, which consists of cutting and joining strips of fabric in staggered rows to create a checkerboard effect.

story quilt Similar to a Bible quilt, a story quilt depicts incidents chosen by the quilter; again, the technique is appliqué.

Underground Railroad A system of cooperation by which freed slaves and abolitionists helped fugitive slaves escape and safely reach the North; also the name of a piecing pattern for quilts.

utilitarian Functional, practical.

white work A quilt with one piece of fabric for the top, or whole cloth quilt, in which the creative emphasis is on the design used to stitch the top, batting, and backing together.

whole cloth quilt A quilt whose top is a single piece of fabric rather than many fabric scraps pieced together.

Where to Learn More About Quilting

Freedom Quilting Bee
Route 1, Box 72
Elberta, AL 36720
(334) 573-2225

African American Quilting Traditions
Web site: http://www.people.virginia.edu/~jkl5c/atrads.html

Michigan's African American Quilters
Web site: http://gopher.sos.state.mi.us/history/museum/
 techstuf/civilwar/quiltmag.html

Now & Then Publications
**(publisher of children's books about quilting, cotton,
 fabric, and crafts)**
Web site: http://www.nowthen.com/

The Quilt Channel
Web site: http://www.quiltchannel.com/

Quilt Talk
Web site: http://www.quilttalk.com/

**Quiltmaker®: Tips, Techniques, and Patterns for
 Today's Quilters**
Web site: http://www.quiltmaker.com/qm/qmindex.html

Quilts, Quilting, and Patchwork in Fiction
Web site: http://www.nmt.edu/~breynold/ quiltfiction.html

For Further reading

Adler, Peter, and Nicholas Barnard. *African Majesty: The Textile Art of the Ashanti and Ewe.* London: Thames and Hudson, 1992.

Freeman, Roland. *A Communion of the Spirits*: *African-American Quilters, Preservers, and Their Stories*. Nashville, TN: Rutledge Hill Press, 1997.

Greene, Polly. *Basic Quilting*. Halifax, NS: Nimbus Publishing/The Nova Scotia Museum, 1992.

Mazloomi, Carol, Cuesta Ray Benberry, Faith Ringgold (Preface). *Spirits of the Cloth: Contemporary African American Quilts.*New York: Clarkson Potter, 1999.

Ringgold, Faith. *We Flew Over the Bridge: The Memoirs of Faith Ringgold*. Boston, MA: Little, Brown & Company, 1996.

Tobin, Jacqueline L., Cuesta Ray Benberry, and Raymond G. Dobard, PhD. *Hidden In Plain View: A Secret Story of Quilts and the Underground Railroad*. New York: Doubleday, 1999.

Index

Credits

Acknowledgments

Thanks and blessings go to: Mary Yearwood, who helped feed my interest, years ago. Maureen Feely, a sharer of her home and quilt collection. Fred Pecker, for helping us find that Double Wedding Ring! SoulSista Marilyn Nance, for beautiful eyes and brains. Quilt preservers and enlighteners Benberry, Freeman, Fry, Thompson, Vlatch and Wahlman: Thanks for the light! My family for their love and patience. The Staff of the Clotworthy Arts Centre, and Antrim Business Centre, Antrim, Northern Ireland for their smiles and facilities. And lastly, Mrs. Williams, and John Blandford, who first nurtured my interest in work with fabric.

About the Author

Sule Greg C. Wilson, M.A., is an educator, writer and musician who began piecing fabric while in high school in Washington, DC, and doesn't do it often enough today! He is the author of *The Drummer's Path: Moving the Spirit With Ritual and Traditional Drumming* and *Kwanzaa! Africa Lives in a New World Festival*, as well as numerous recording projects. Wilson currently resides in Tempe, Arizona, with his wife Vanessa, daughters Shepsut and Senbi Saa, mother-in-law Barbara Thomas and Squirrel, the Abyssinian/Burmese cat.

Photo Credits

Cover photo, pp. 4–5, 36, 51 Everett Collection; p. 2, students and parents of students of Eula G. Williams, photo by Mark Eifert courtesy of Michigan State University Museum; pp. 8–9 CORBIS/Jaqui Hurst; p. 10, 23–29 Newark Museum/Art Resource, NY; pp. 11 Justine Burnell, photo by Mark Eifert courtesy of Michigan State University Museum; p. 15 CORBIS/Gianna Dagli Orti; p.16 CORBIS/Philadelphia Museum of Art; p. 17 CORBIS/Asian Art and Archaeology, Inc.; p. 19, 31, 37, 39, 47, 55 CORBIS; pp. 20–21 CORBIS/Robert Holmes; p. 30 CORBIS/Marc Garanger; p. 32, 40 CORBIS/Caroline Penn; p. 33, 41 © North Wind Pictures; p. 35 Rosie L. Wilkins, photo by Mark Eifert courtesy of Michigan State University Museum; p. 38 Maria Ingersoll Snipes, photo by Mark Eifert courtesy of Michigan State University Museum; p. 38–39 CORBIS/Kevin R. Morris; p. 42 Museum of Fine Arts Boston; p. 45 Smithsonian Institution; p. 46 CORBIS/Contemporary Art Collection; p. 48 Wednesday Quilting Sisters, photo by Mark Eifert courtesy of Michigan State University Museum; p. 53 Mildred Chenault, photo by Mark Eifert courtesy of Michigan State University Museum; p. 54 CORBIS/Richard Oliver; p. 56 Denise Curtis Reed, photo by Mark Eifert courtesy of Michigan State University Museum.

Design and Layout

Series Design: Laura Murawski

Layout: Oliver Halsman Rosenberg

Consulting Editors

Erin M. Hovanec and Erica Smith